David Chapman

VICTOR VICTORIANS

JANSSEN

Many thanks for David Berryman for his help on this project.

© **JANSSEN PUBLISHERS CC**
P.O.Box 404, Simon's Town 7995, South Africa

Production: Fotolito Longo AG

Printed in Italy 2004

ISBN (international) 1-919901- 16-7
ISBN (Germany) 3-931613 - 67-4

Inquiries: info@janssenbooks.com
Publisher's Office: janssenp@iafrica.com

Please visit our website: **www.janssenbooks.co.za**

Victor Victorians:
Early Photographs of the Muscular Male

by David Chapman

The male nude has been the subject of art since ancient times, but its popularity has waxed and waned over the years according to tastes and times. Beginning in the 1800's, there was a tremendous rise of interest in images of the muscular male body, and this fascination with physical power, symmetry and male beauty can be traced back to that essentially masculine occupation: war. Whenever young men have been sent out to fight their country's battles, they have stimulated an interest in strength and muscularity; this is precisely what happened shortly after Napoleon began his conquests. Both the conquered and the conquerors began to realize that part of the reason for their nation's performance in battle rested on the physical prowess of their fighters. Soon, the armies of western Europe were studying methods to increase the endurance and strength of their troops, and conscripts from Britain to Bohemia consequently learned how to hone and enlarge their muscles. But there were other movements afoot, too, and soldiers were not the only ones who took pleasure and pride in their newly muscular physiques.

The mid-nineteenth century is sometimes called the Age of Revolutions because of all the political turmoil that took place at this time, but there were also a few social convulsions that coursed through European society. One of these was a sporting movement that was gaining strength and popularity. Britain was the first country to enter the industrial age, and along with new machines and products, the new factories also created a stable middle class. As more ordinary people had the leisure to devote to pursuits other than basic necessities, they could turn their attention to other things; one of the things that they chose to participate in was sport. Physicality, muscularity and the bonds formed while participating in sports eventually became advantages on the playing fields of Eton as well as in the board room of corporations. Another phenomenon that called attention to the developed male body was the variety theater. Called Vaudeville in North America and Music Hall in Britain, this popular entertainment brought together jugglers, song-and-dance teams, trained dogs, standup comedians and professional strongmen. These latter made their livings by lifting various heavy objects or performing stunts calling for both nerves and sinews of steel; more importantly, they also accustomed the public to looking at strong male bodies as a form of entertainment. Most theatrical strongmen before the 1890's were not paragons of masculine beauty: their massive, bulky bodies were covered with Roman sandals, pink tights and leopard skins.

All that changed in 1893, however; in that year an obscure East Prussian athlete named Eugen Sandow began to perform at Chicago's World's Fair. Sandow was the first vaudeville performer to discover that he could entertain audiences just as effectively by displaying his beautifully sculpted physique rather than by lifting weights. Soon, Sandow as well as his lookalikes and wannabes were showing off the male body in a way that could not have been imagined a few decades earlier. Sandow became a phenomenally successful figure in the twin worlds of sport and physique display. The German strongman also realized that others would pay to have a body as well developed as his, and he eventually opened up a string of gymnasiums around the world allowing him to become one of the most prosperous men in the sporting world. The techniques that Sandow had pioneered in the realm of posing were copied by other athletes and photographers to display the nude (or nearly) male body in ways that might seem surprising to those who think of the Victorian and Edwardian eras as restrained and repressed.

So the Napoleonic wars had caused nations to invest in scientific exercise to build the bodies of its soldiers, and this in turn had led to new bodybuilding techniques. The newly prosperous middle class had become interested in sports as a way of spending leisure time, and finally Sandow's vaudeville performances had shown everyone the potential of muscularity of which the masculine body was capable. There was only one more piece of the physique puzzle that remained: how best to record those newly muscular bodies? Photography was obviously the answer. This art had been invented in the 1840's, and despite toxic chemicals, bulky equipment and long exposure times, by the end of the century photos had became an increasingly popular means of capturing faces and physiques. One of the earliest and most popular forms of male nude photography was the académie. These were used by artists to reproduce poses in paintings or sculptures, and they are recognizable by their use of artificial poses, exaggerated facial expressions and formal compositions. As their name implies, académie photos were meant to mimic the antique statuary that art students were taught to copy in the leading art schools of the day.

Another genre of photography that was used extensively is the "physique" photograph, but this type is more difficult to define because of its nebulous nature. Ostensibly, the purpose of physique photographs is to display the subject's musculature, so the men in these pictures tend to be consciously flexing or otherwise showing their physiques to best advantage. Problems arise, however, when we realize that there was a great deal of crossover between the physique and the académie photo: sometimes the académie models show an impressive amount of muscle, and at other times the bodybuilders pose in imitation of ancient statuary. Because they wanted to recreate Greco-Roman art as closely as possible, many of the athletes in these photos resorted to

fig leaves, wispy draperies or simply strategically placed limbs to cover their genitals. Only the bravest, boldest or most insouciant of early musclemen chose to have themselves photographed in complete frontal nudity. Nineteenth and early-twentieth-century physique models seemed to have few qualms about posing as close to complete nudity as decency would allow, but very few big-name athletes let themselves be recorded on a photographic plate without at least a small cache-sexe for the sake of modesty. Some photographers went to the extreme of scratching out the area on the negative in order to remove all vestiges of the offending organs. Not until the 1920's and 30's would the Freikörperkultur (or nudist) movement change attitudes in Europe and North America about the health and spiritual value of removing one's clothing.

Another revelation to modern viewers is the variety of posing styles that are represented in these photographs. Oldtime bodybuilders were not afraid of trying new and different means of showing off their muscles. They would willingly use costumes, props or other items to make the pictures more dramatic or beautiful; thus, viewers will find swords, animal skins, Roman sandals and other outlandish items in abundance. Victorian bodybuilders did not feel constrained to have their pictures taken merely in a double-biceps pose, and that is a lesson that modern athletes might take to heart.

Both the world and muscular photography changed irrevocably after World War I began in August of 1914. Just as Napoleon had been the unwitting catalyst of the first sporting movement, Kaiser Wilhelm was the unknowing reason for the second great change. The charm, grace and quaintness that we ascribe to the images from before the war were replaced with different sensibilities. As the era of ragtime was replaced by the Jazz Age, life (like the music) picked up its pace and tastes changed; thereafter, few men chose to have themselves photographed in leopard skins and Roman sandals.

Thanks to these beautiful photographs, however, we have a precious souvenir of the men and the methods they used to record themselves.

ACADÉMIES

Among the earliest of all male nude photographs are those that were made as aids for artists. The principal aim of these pictures is not to present the subjects' muscles or athletic ability but to provide easily copied figures for the statues and paintings that were so popular in the nineteenth century. These académies (so called because they were often used in art academies) are characterized by artificial and overly arty poses and frequent use of mirrors to give students a full view of the subjects. Most académie photos come from Europe where a century ago there was a minor industry in the production of these pictures.

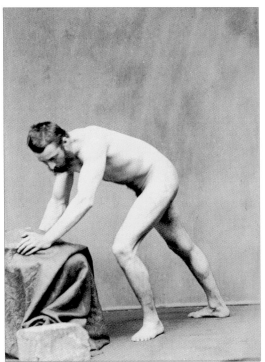

Anonymous subject and photographer; circa 1880

7

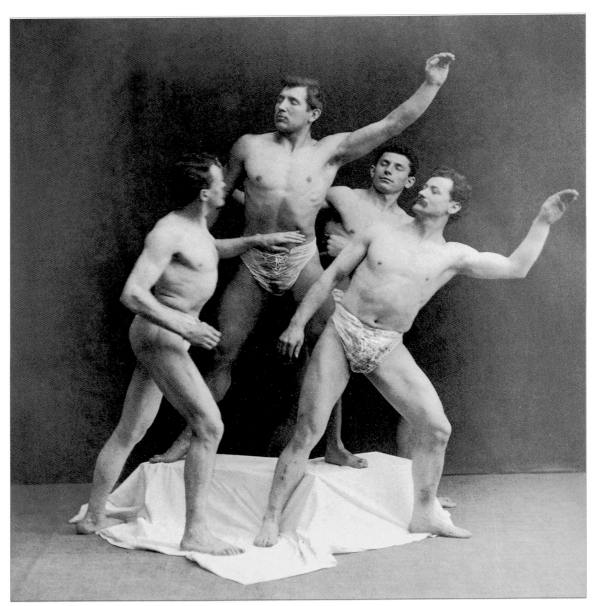

Photographer: E. Hind; circa 1890

8

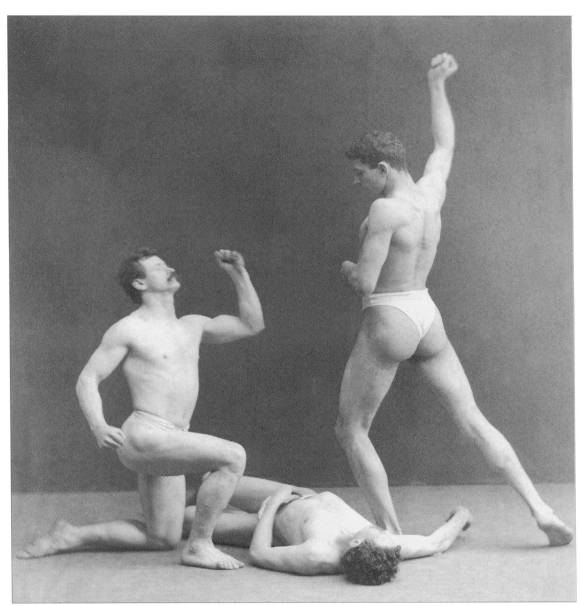

Photographer: E. Hind; circa 1890

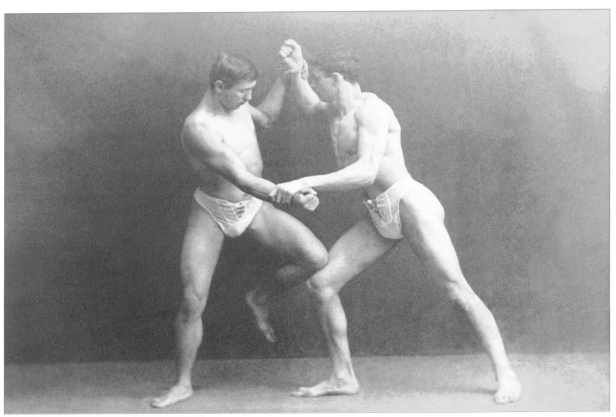

Photographer: E. Hind; circa 1890

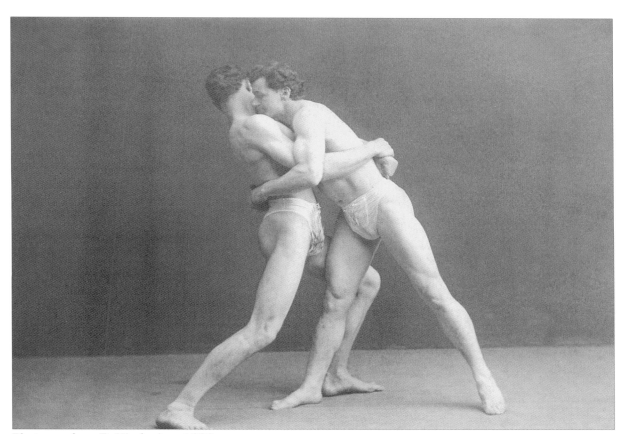

Photographer: E. Hind; circa 1890

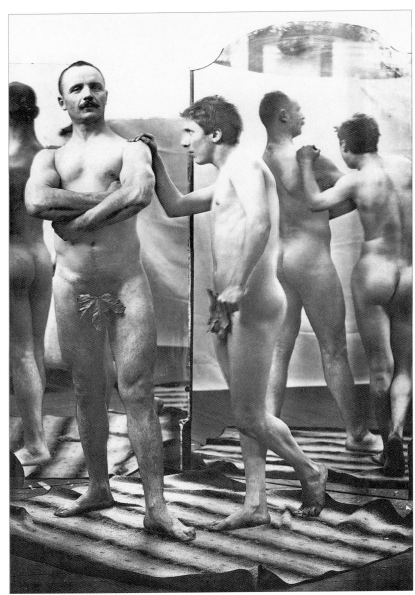
From "Le nu esthétique" published in France by Bayard; circa 1902

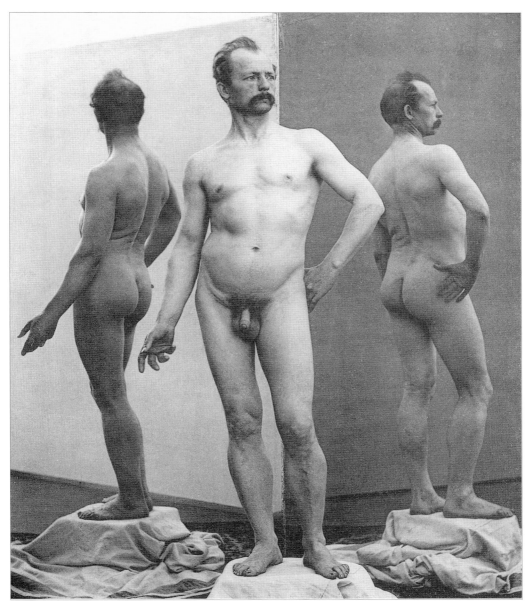

From "Der Act" by Max Koch and Otto Rieth; Germany, 1894/95

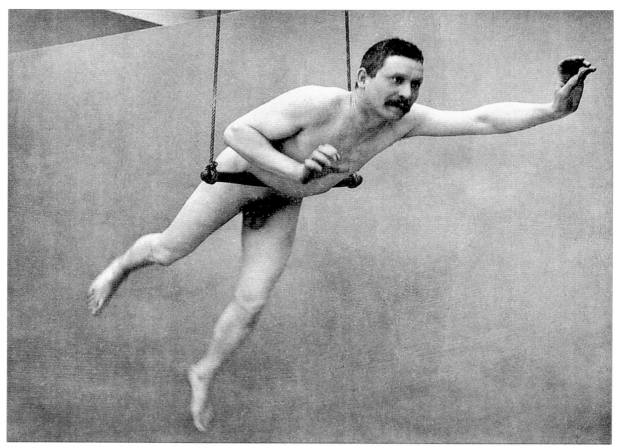

From "Der Act" by Max Koch and Otto Rieth; Germany, 1894/95

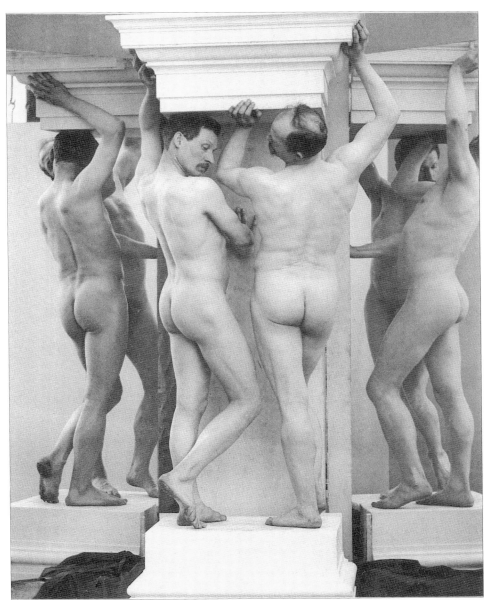

From "Der Act" by Max Koch and Otto Rieth; Germany 1894/95

15

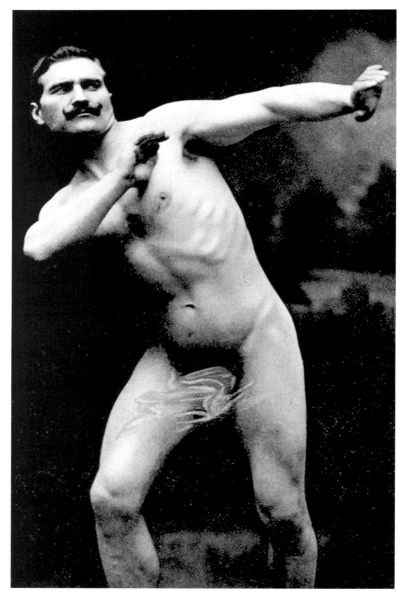
Anonymous subject and photographer; French, circa 1900

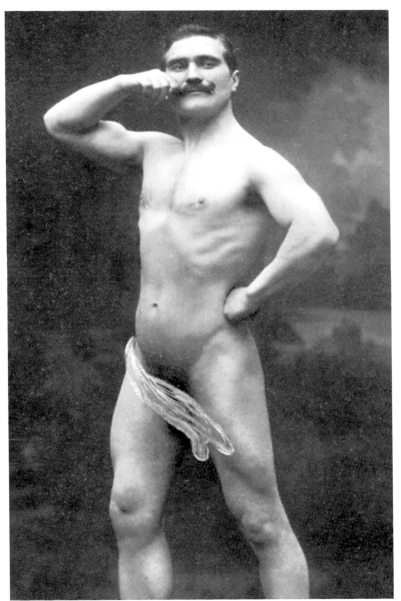

Anonymous subject and photographer; French, circa 1900

LIVING STATUES

One of the most effective ways of legitimatizing photographs of the nude was to imitate classical statuary. There might be fewer objections to viewing a nude human assuming the attitude and appearance of an ancient statue than if he or she were in a more natural pose. It did not take long for enterprising showmen to figure out that this might be an excellent way of displaying more flesh on the variety stage. The Seldoms, for instance, had a "living statuary" turn which they performed to great acclaim on music hall stages all over Britain; they dusted themselves with white talc to appear even more statuesque and then posed motionless on pedestals. Athletes and bodybuilders discovered that they, too, could pose for and sell copies of photos if they made themselves look like statues.

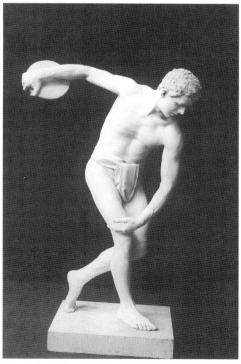

"The Disc Thrower"; The Seldoms, circa 1910

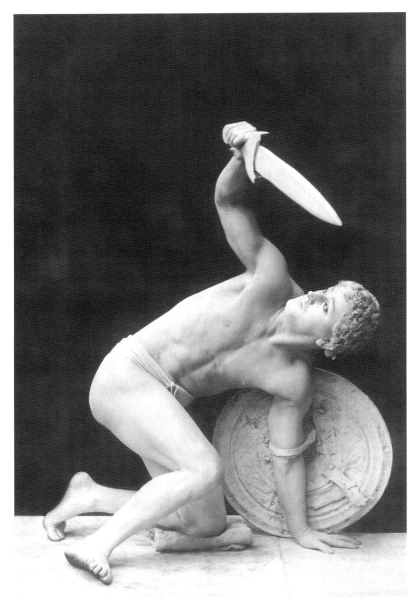

"The Gladiator"; The Seldoms, circa 1910

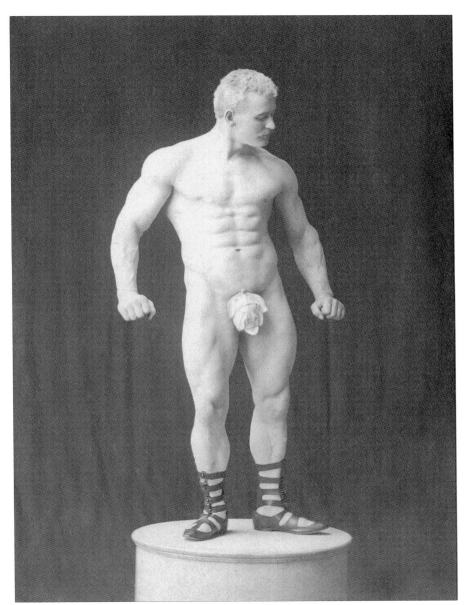

Eugen Sandow; photographer unknown (probably American), circa 1894

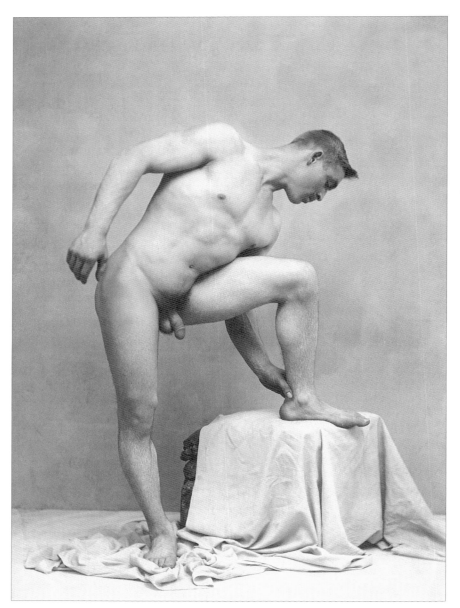

Adrien Deriaz; French, circa 1900

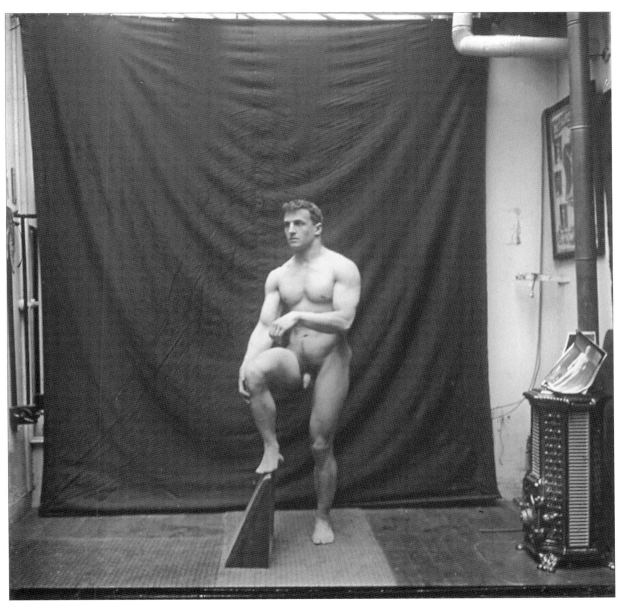

Enrico Brancaccio as "Athlete applying oil" by Edmond Desbonnet, circa 1912

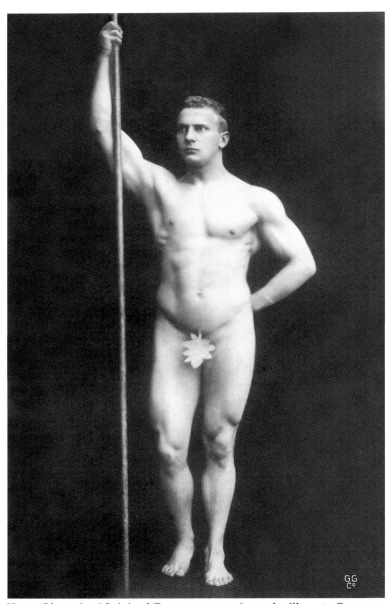

Hans Olympier "Original Bronzestatuen" vaudeville act; German, circa 1910

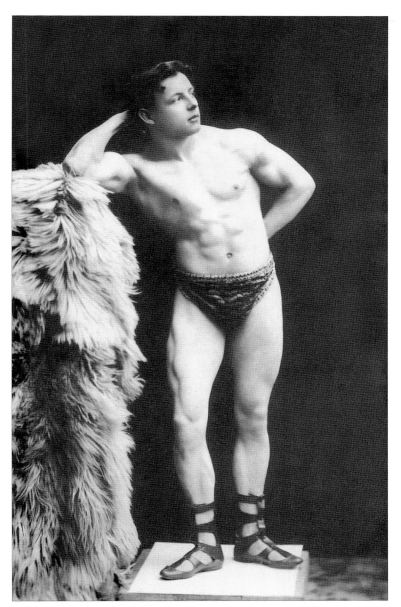

Hans Schmelzkopf; German, circa 1910

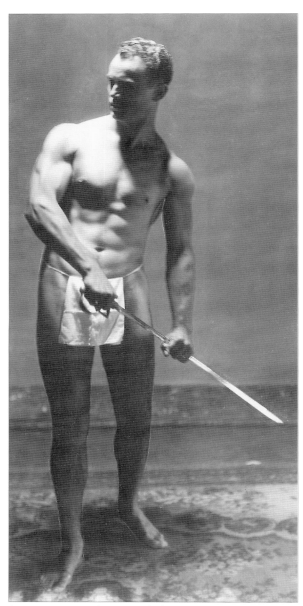

Anonymous subject and photographer; American,
circa 1920

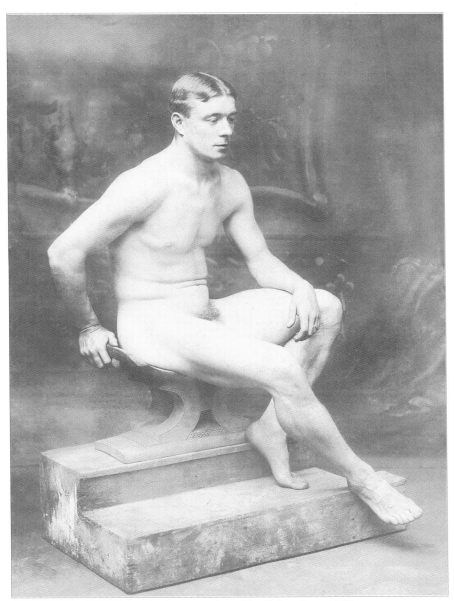

Anonymous subject and photographer; English, circa 1900

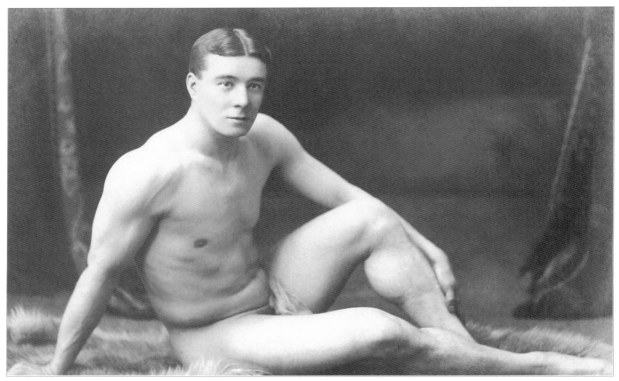

Anonymous subject and photographer; English, circa 1900

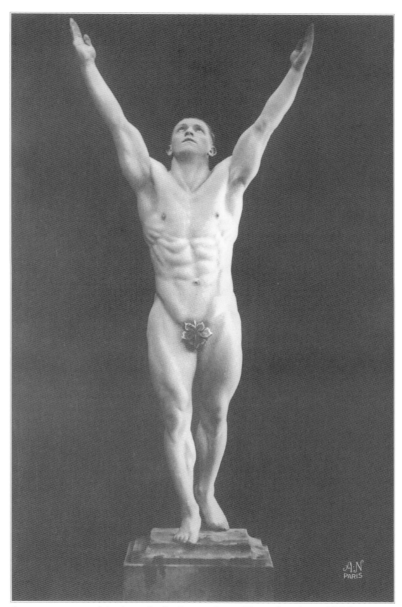

Anonymous subject and photographer; French, circa 1920

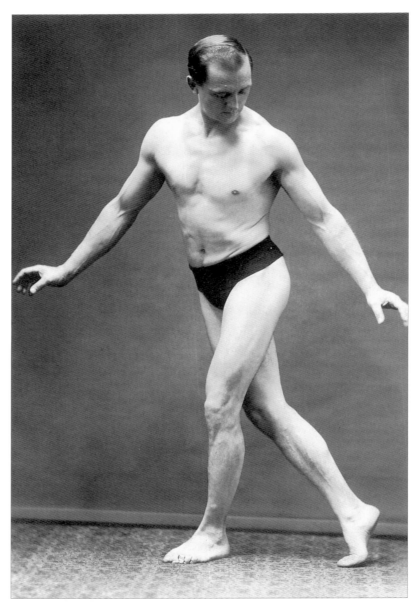

Frank Reckless; American, circa 1925

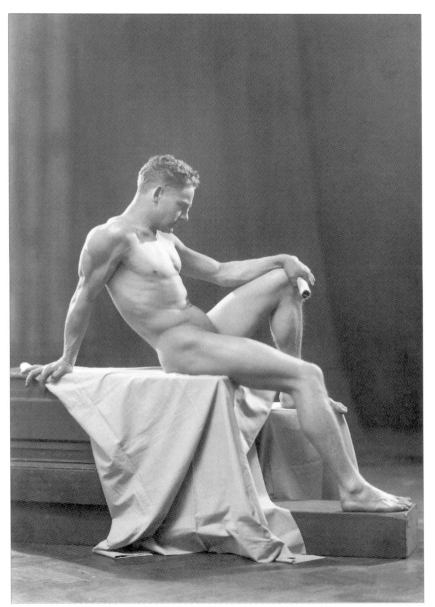

Lawrence Woodford; English, circa 1935

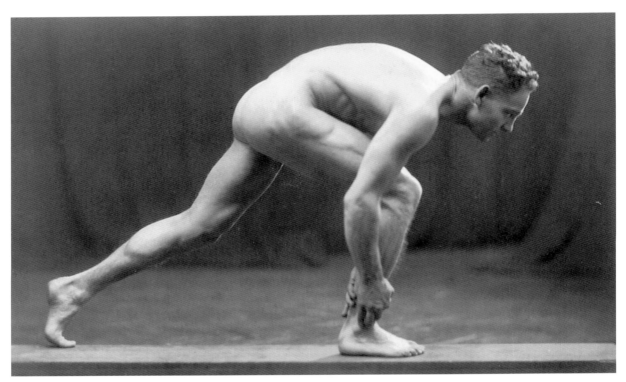

Lawrence Woodford; English, circa 1935

ATHLETES

Muscular men seem most natural when they show off their strength, skill or aggressive tendencies for the camera. They also like to have their pictures taken with their friends or team mates. Thus, another important sub-genre of photography is the sports or action picture.

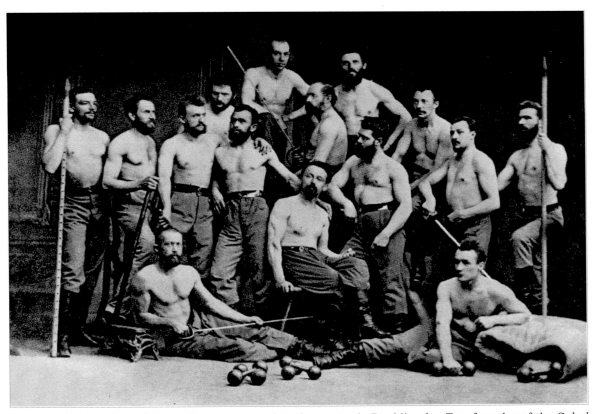

A group of Bohemian athletes; the man seated in the center is Dr. Miroslav Tyr, founder of the Sokol movement which combined Czech nationalism with athletics; Prague, 1876

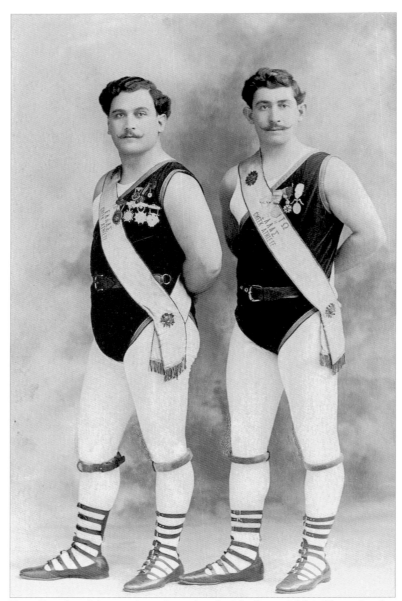

Two Greek athletes; American (probably from 1904 Olympics in St.Louis.

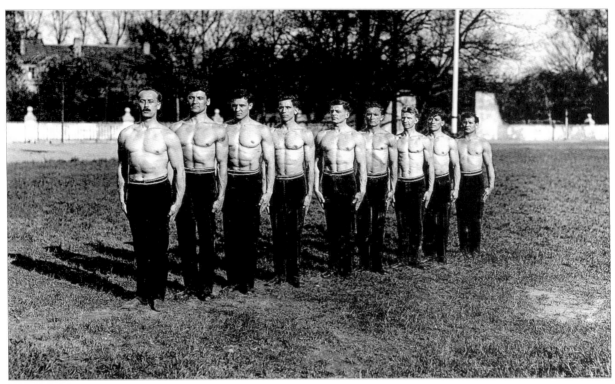

Group of shirtless Sokol athletes; Czechoslovakia, circa 1930

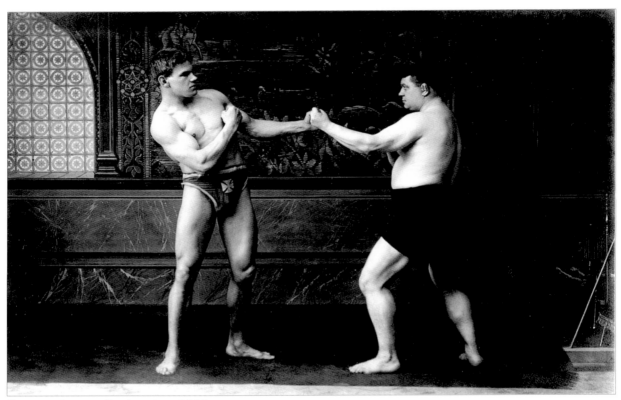

Two sportsmen; Spain, circa 1910

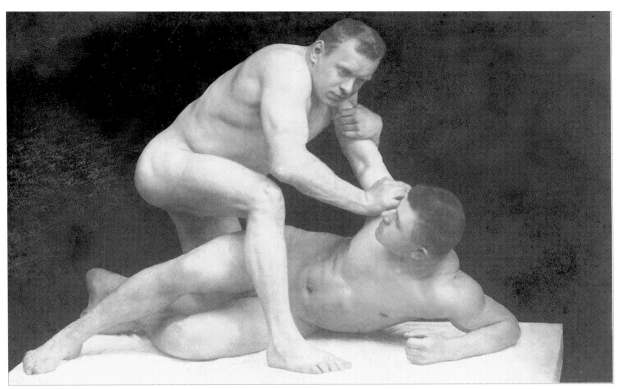

Professional wrestlers Georg Lurich and Karl Pospeschil; Russian, circa 1910

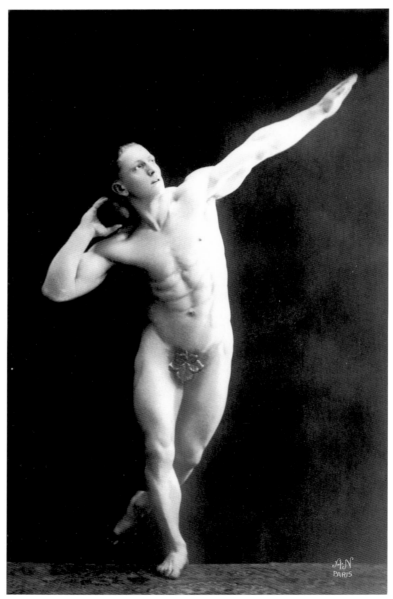

Shot putter; French, circa 1920

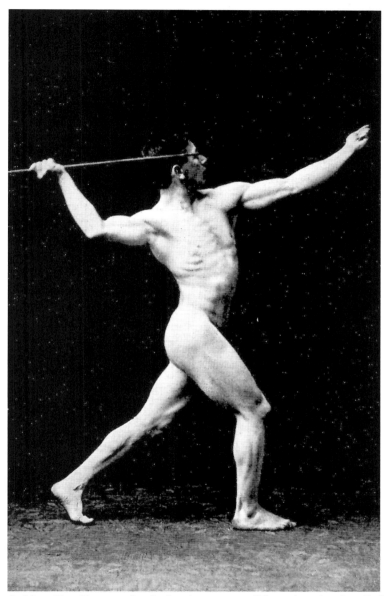

A. Llewellyn Evans, physical cultur expert "Throwing the Javelin",
circa 1910

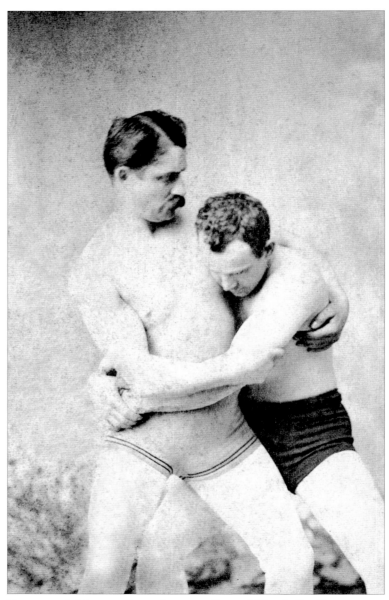

Bauer and Adams, champion wrestlers; J.Wood, the Bowery -
New York, circa 1870

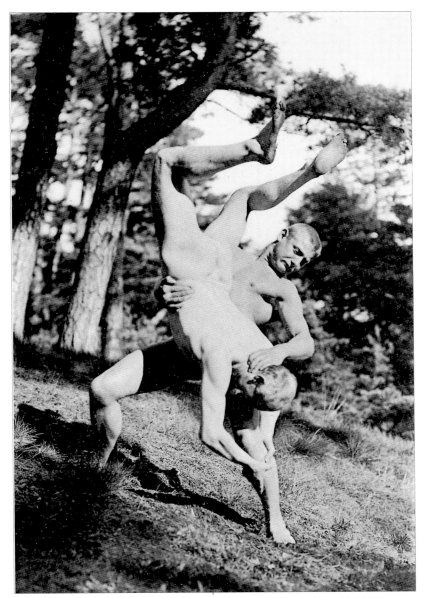

From "Freilicht" by Max Koch; Leipzig, Germany, circa 1900

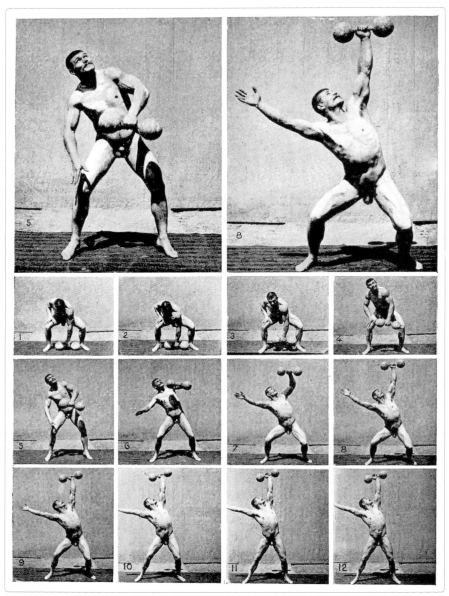

"Arracher de l' haltère" from "Nouvelle anatomie artistique" by Paul Richter and Albert Londe; Paris 1911

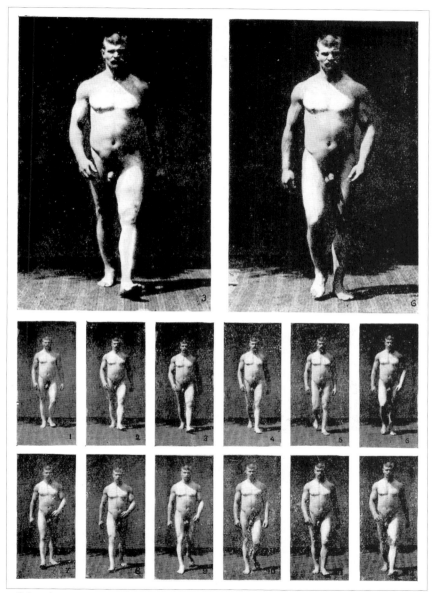

"Marche sur terrain horizontal" from "Nouvelle anatomie artistique"
by Paul Richter and Albert Londe; Paris, 1911

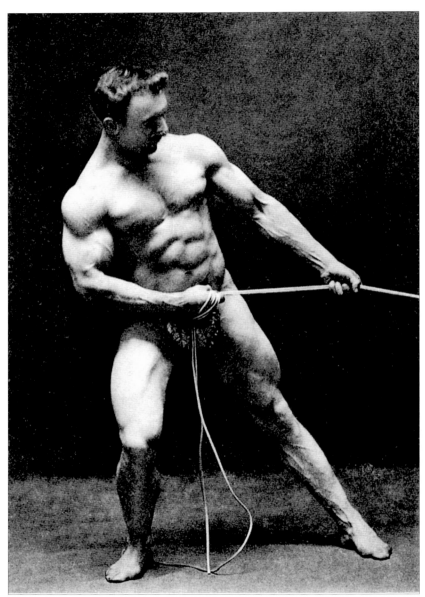

Bobby Pandour pulls a rope; French, circa 1900

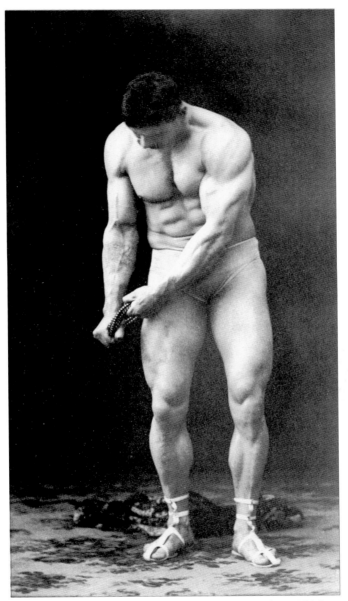

Anymous athlete twisting cables; German, circa 1912

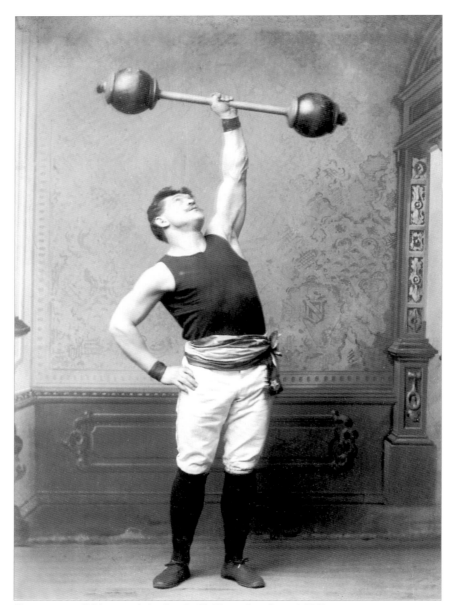

Strongman lifting a globe barbell; French, circa 1895

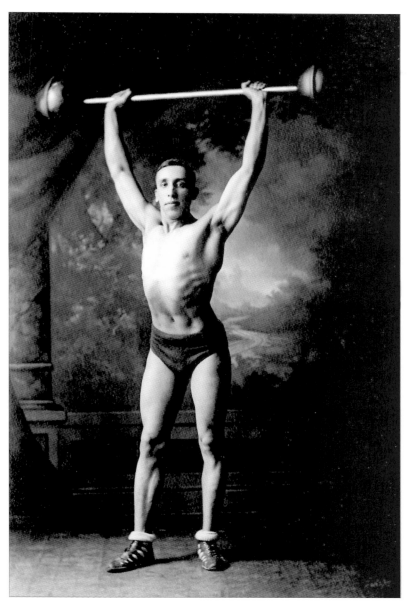

Identified as "Zapata" on reverse; Mexican, circa 1915

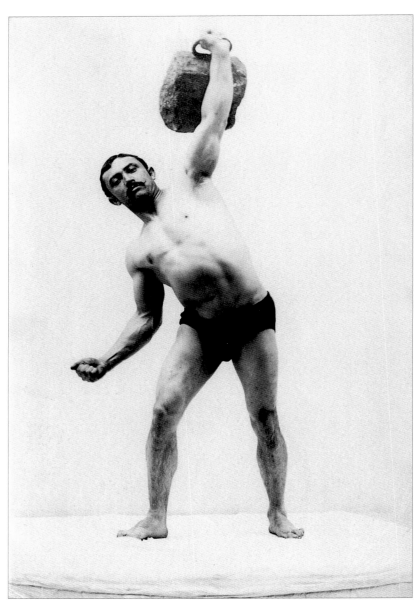

Strongman lifts a stone with one arm; French, circa 1895

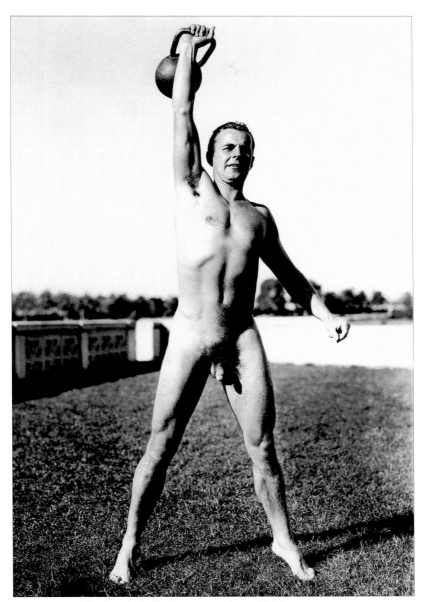

Nude man lifts kettle bell; German, circa 1920

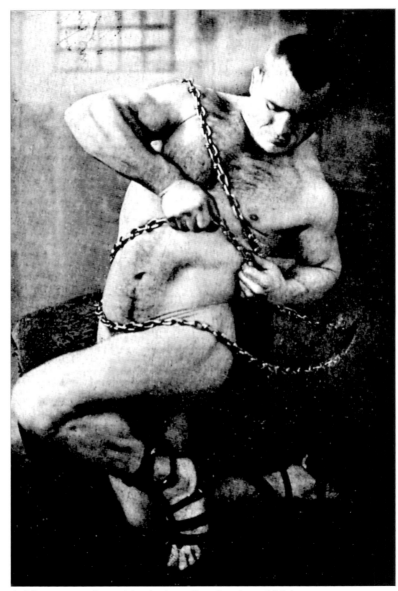

Athlete struggles with chains; Czech, circa 1914

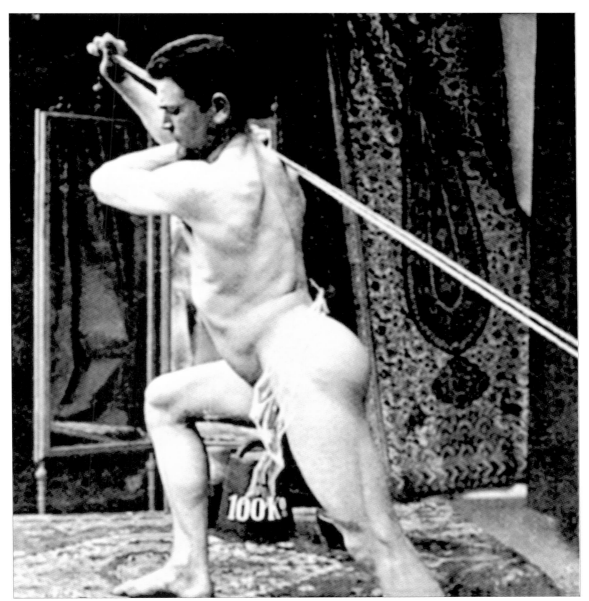
Strongman; stereoview, circa 1895

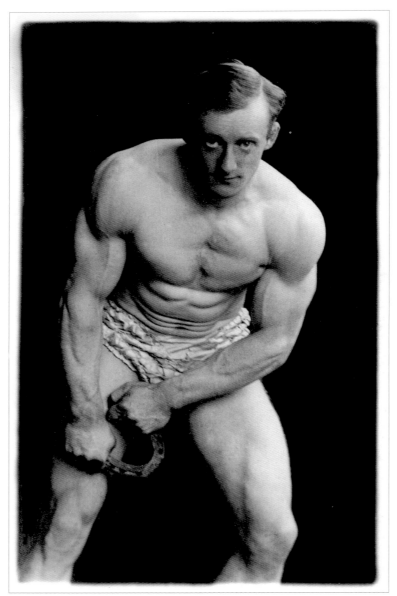

Willy Saares bends a horseshoe; Dutch, circa 1910

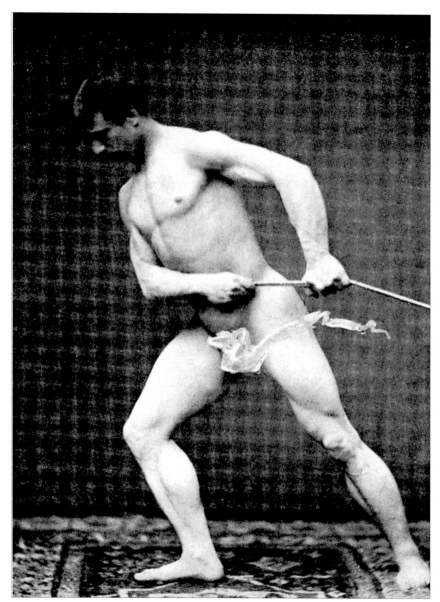

Rope puller, French, circa 1900

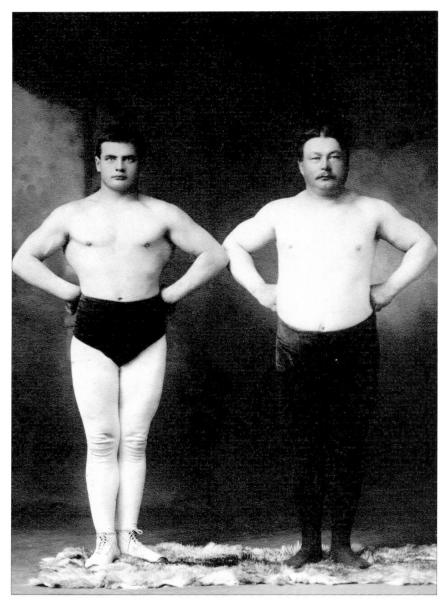

Father and son athletes; American, circa 1895

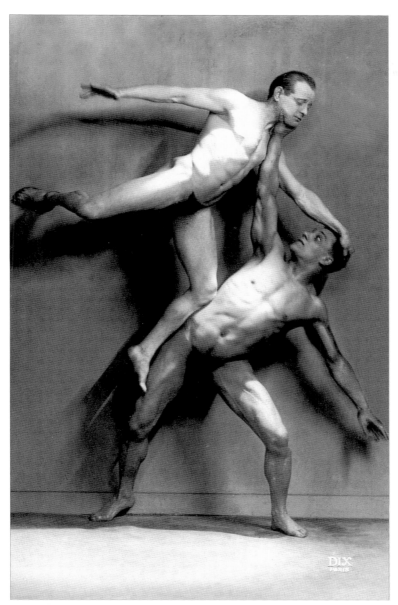

Les Athéna; French music-hall athletes, circa 1920

PHYSIQUES

By far, the most common way for muscular men to have themselves immortalized on film was to pose for a physique photograph. The goal of this genre is to display the muscles as clearly and accurately as possible, and in many of the pictures the models will flex or contort their bodies so as to display musculature as clearly as possible.

According to the traditions of Western art, "women appear and men act." A man who does nothing but expose his body for the camera therefore risks being feminized; a red-blooded male must do something while he is being photographed, even if it is merely to flex his muscles as his image is captured by the camera. Clearly, a few of the photos in this section overlap into other genres, but if the viewer looks closely, he can see that each man displays his musculature in some form.

These pictures are highly competent and skillfully done, but even though the more sophisticated photographers often adopted the trappings of art or salon portraiture,

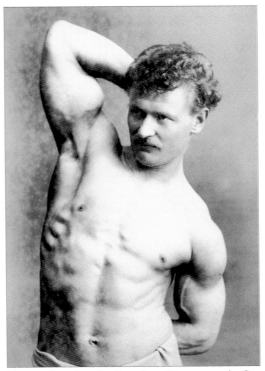

Eugen Sandow by London Stereoscopic Co.; London, 1889

57

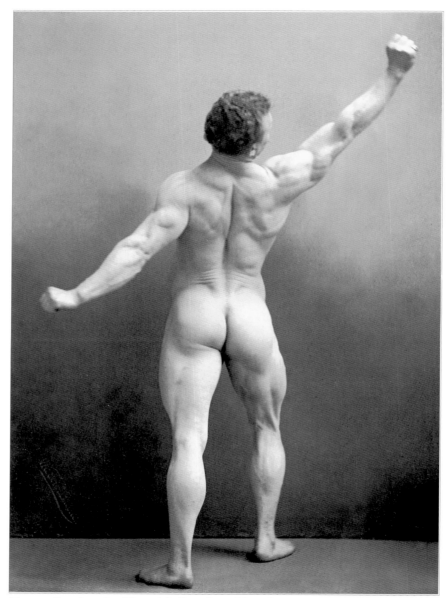

Eugen Sandow by Warwick Brookes; Manchester, England, circa 1895

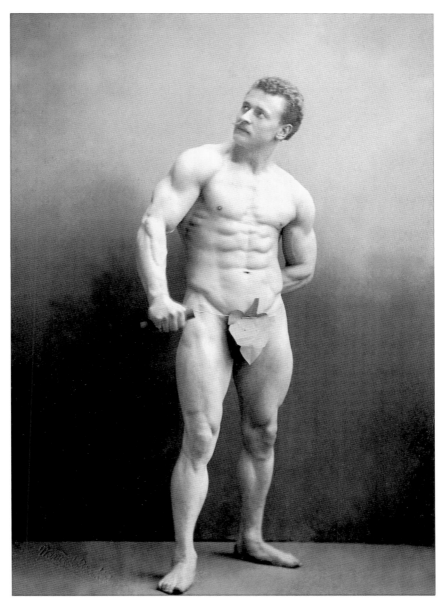

Eugen Sandow by Warwick Brookes; Manchester, England, circa 1895

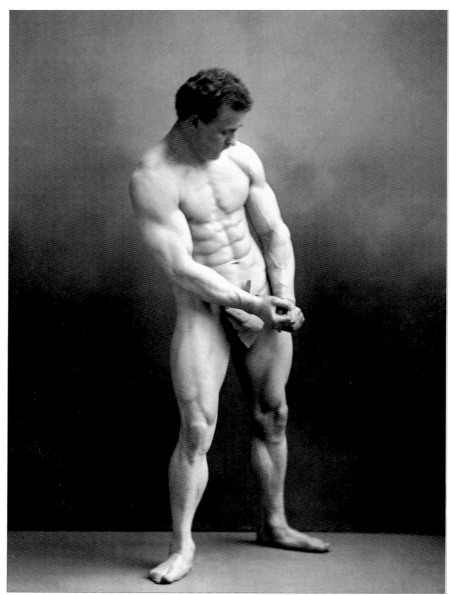

Eugen Sandow by Warwick Brooks; Manchester, England, circa 1895

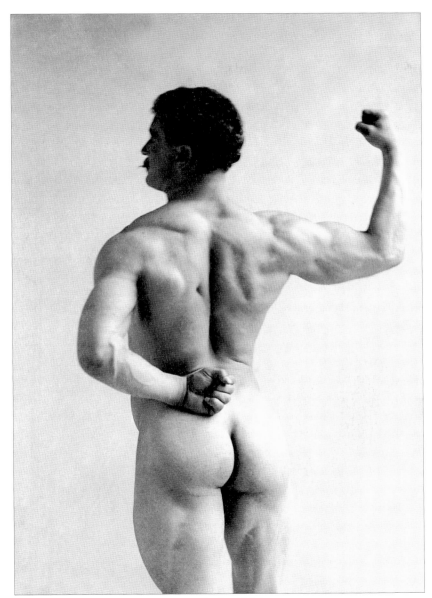

Eugen Sandow by Sarony; New York, 1894

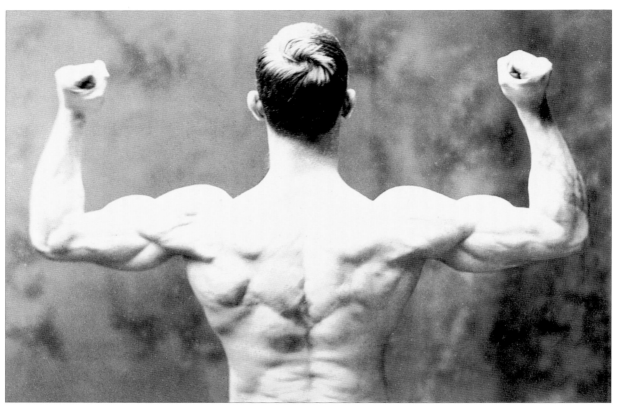

Charles Vansittart by Hana; London, circa 1899

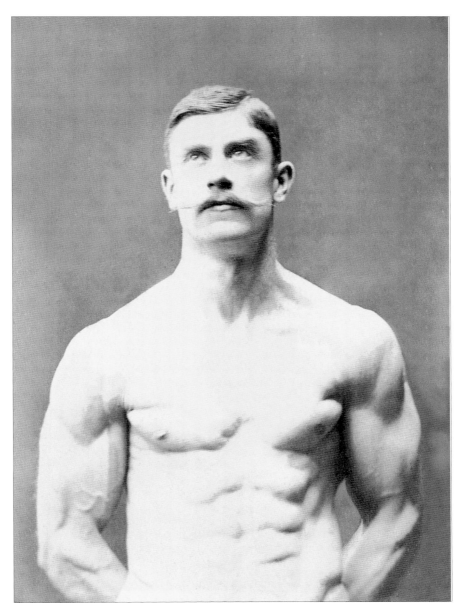
Charles Vansittart by Hana; London, circa 1899

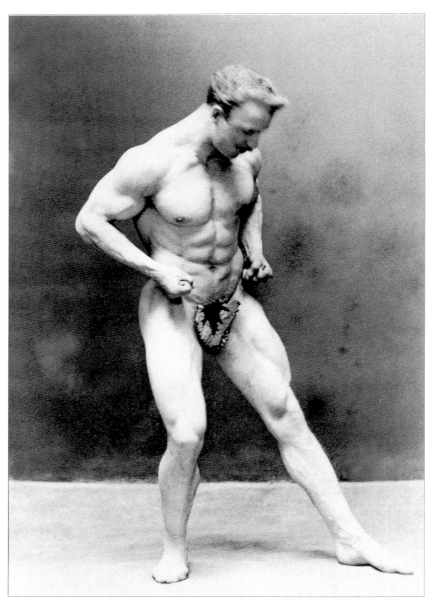

Bobby Pandour; France, circa 1900

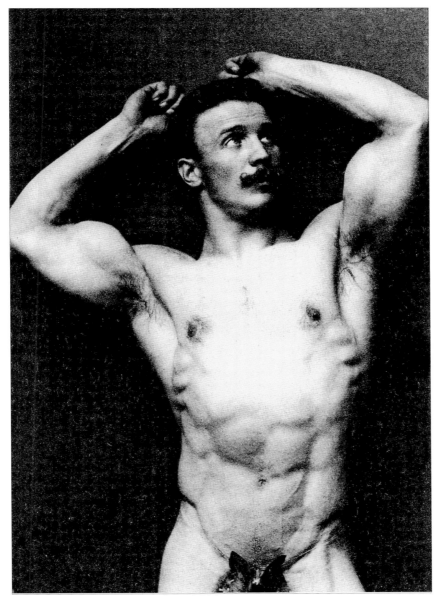
Bobby Pandour; France, circa 1900

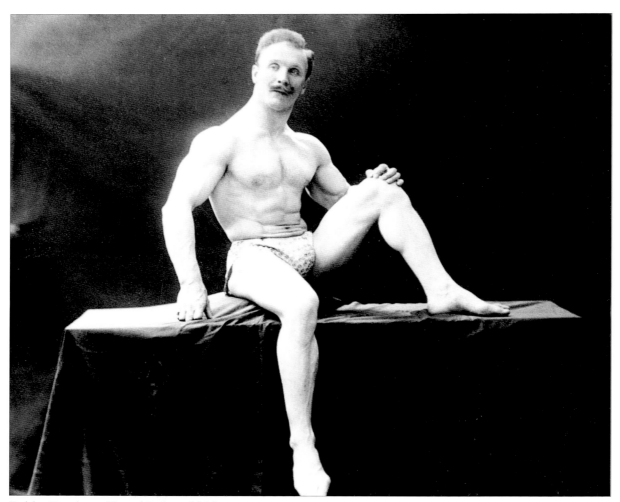

Bobby Pandour; France, circa 1900

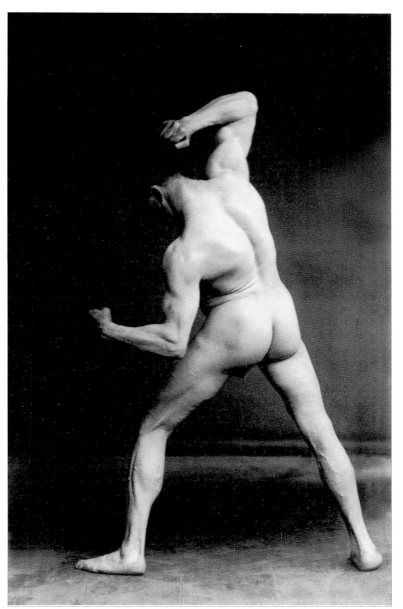

Anonymous subject and photographer; France, circa 1895

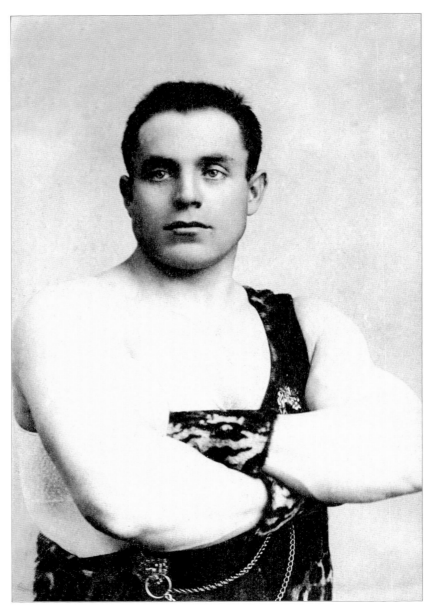

John Grün Marx by John Weir; Glasgow, circa 1905

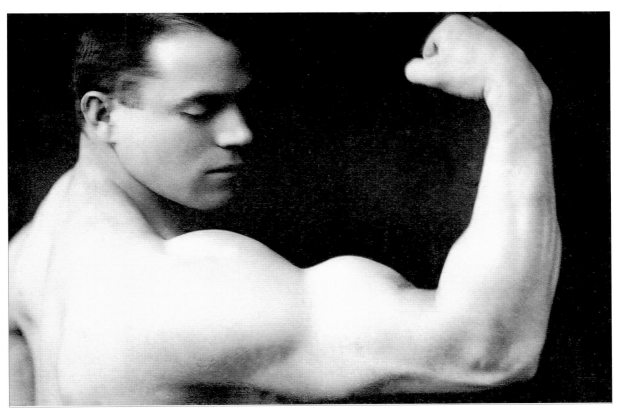

John Grün Marx by Wallis Weir; Glasgow, circa 1900

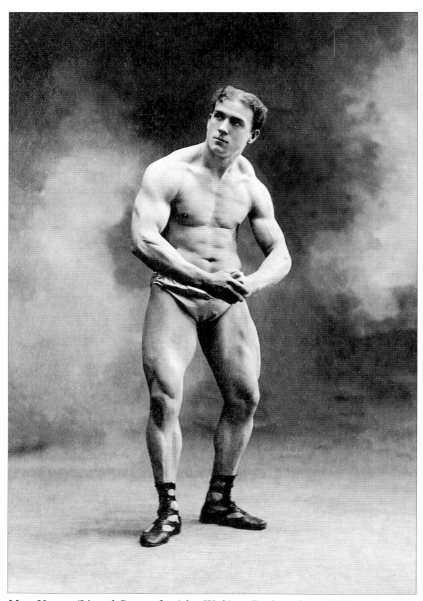

Max Unger (Lionel Strongfort) by Waléry; Paris, circa 1900

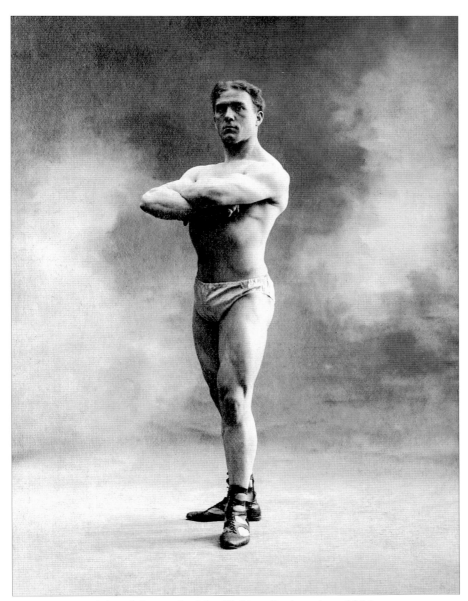

Max Unger (Lionel Strongfort) by Waléry; Paris, circa 1900

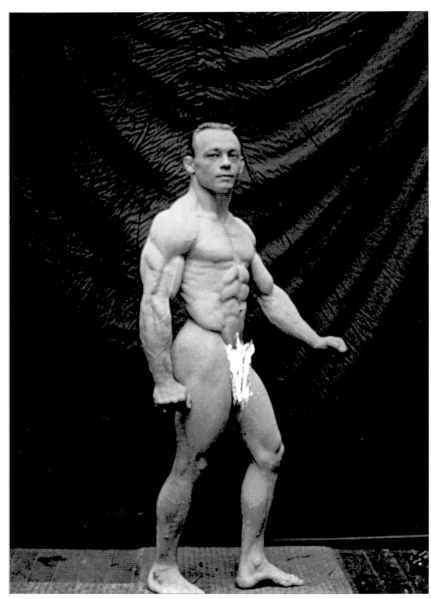

Otto Arco by Edmond Desbonnet: autochrome stereoview, Paris 1913

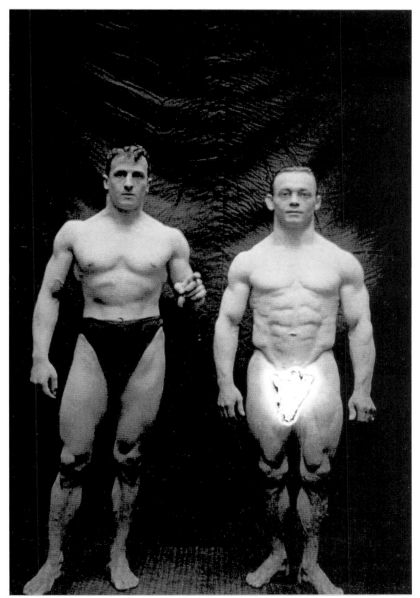
Otto Arco by Edmond Desbonnet: autochrome stereoview, Paris 1913

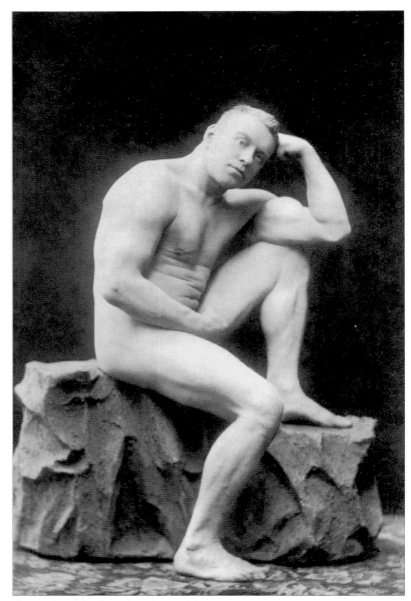

Georg Lurich; Russia, circa 1900

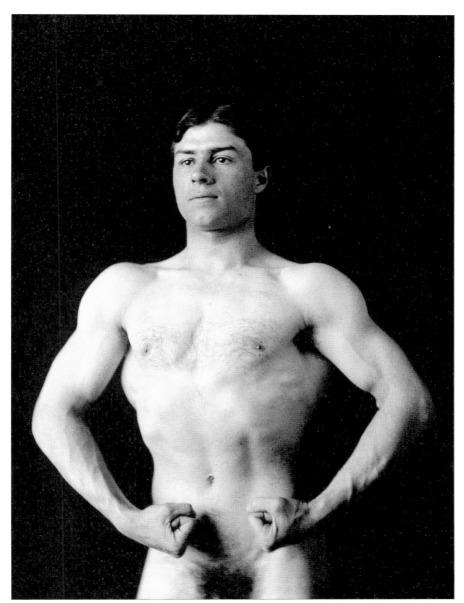

Anonymous subject and photographer; American, circa 1900

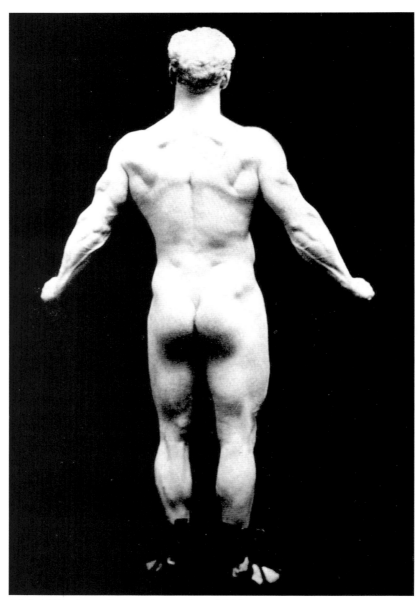

Adolph Nordquest; American, circa 1915

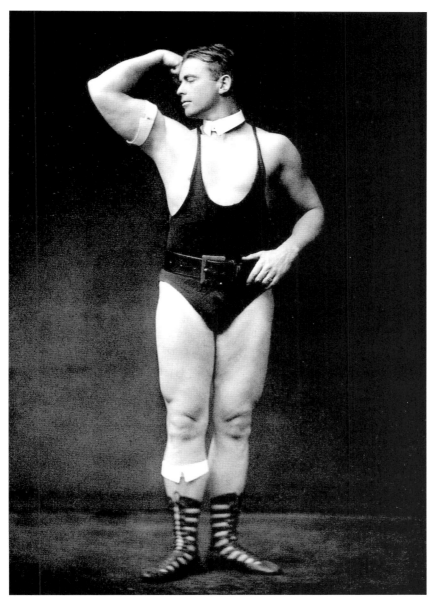

Arthur Gay by C.F.Schlitzer; Rochester, N.Y. Circa 1917
Gay demonstrates that his collar size matches his biceps and calf.

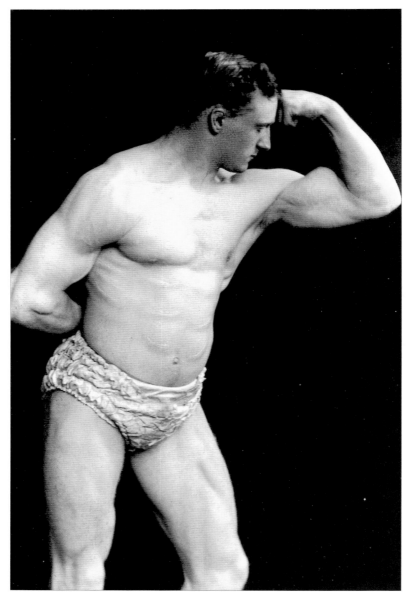
Willy Saares; Dutch, circa 1910

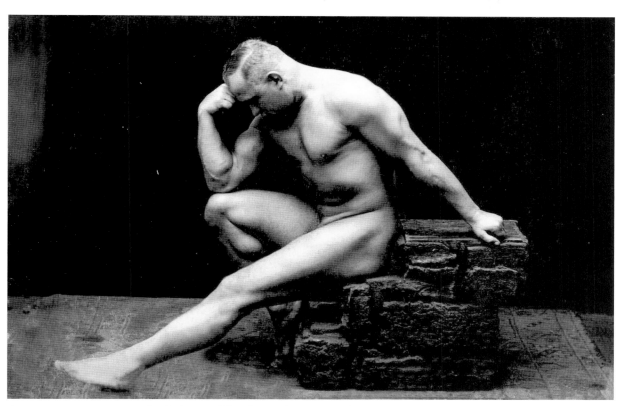

Anonymous strongman by Reimers; Hamburg, Germany, circa 1900

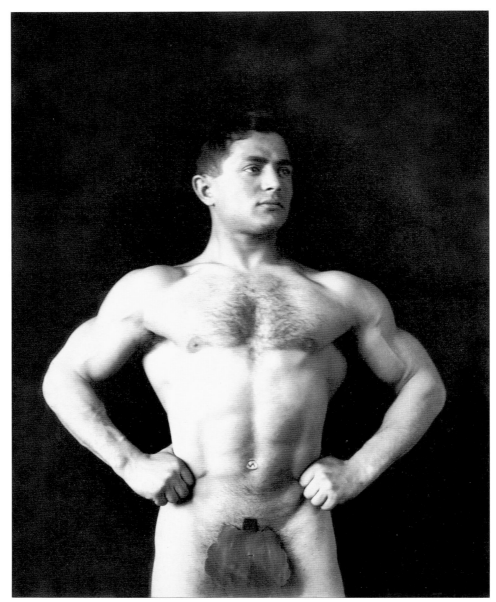

Abe Boshes; American, circa 1915

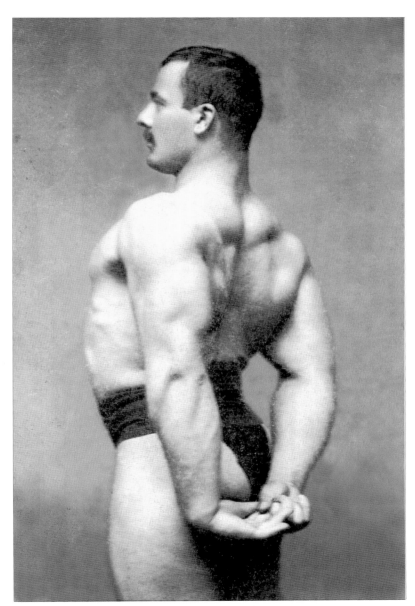

Stanley Zbyszko by Renner; Vienna, 1900

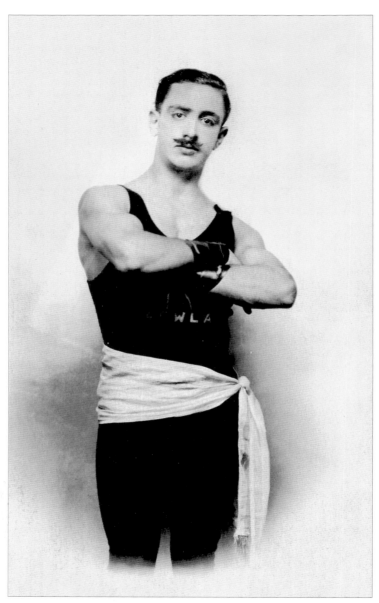

A. Parotto wearing jersey of the American Continental Weight
Lifting Association; American, circa 1915

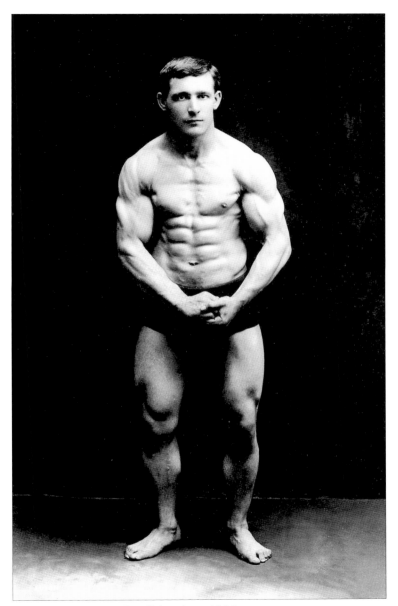

F. Beck by Luton; English, circa 1910

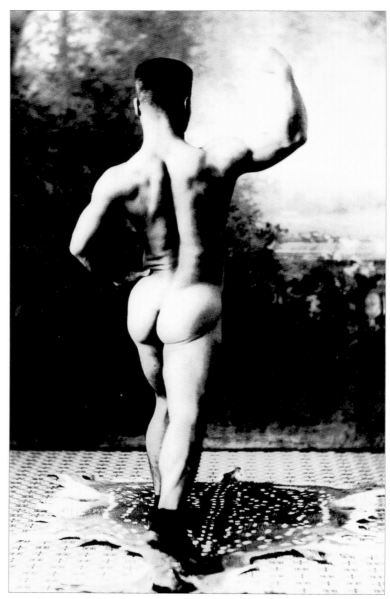

Isao Toyama of Makawo, Maui; circa 1920

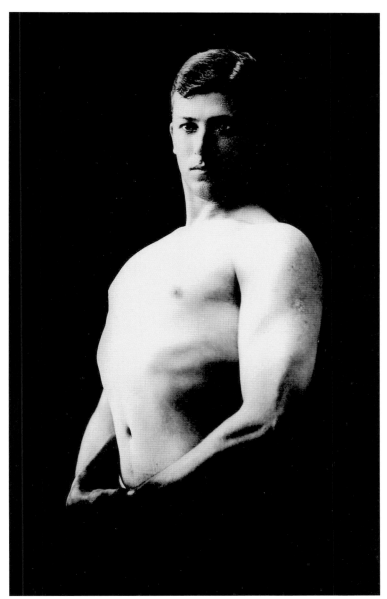

Stanton Smith; American, circa 1925

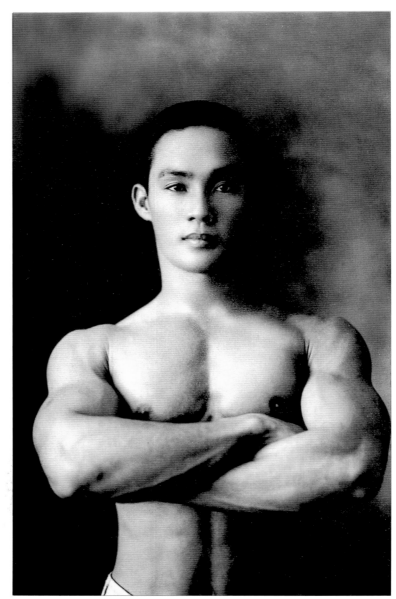

Bernardino Ovano of Cebu City; Philippine, 1924

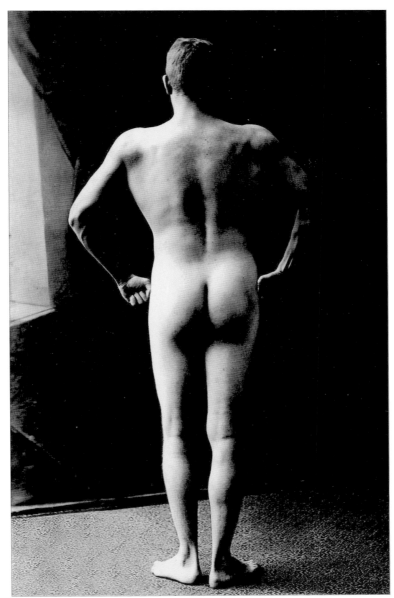

Stanton Smith; American, circa 1925

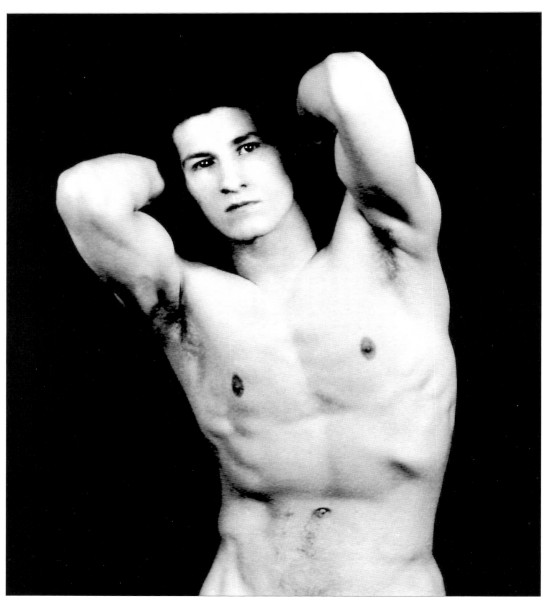

George Yacos, athlete and gym owner from Detroit; 1936

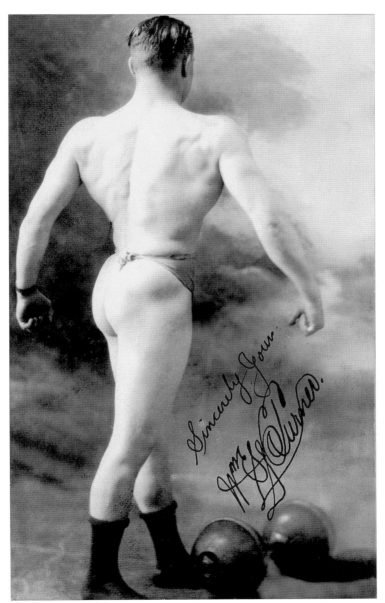

William Turner; American, 1925

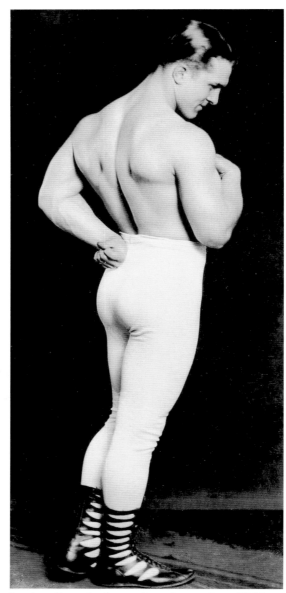

Lurton Cunningham; American, circa 1925

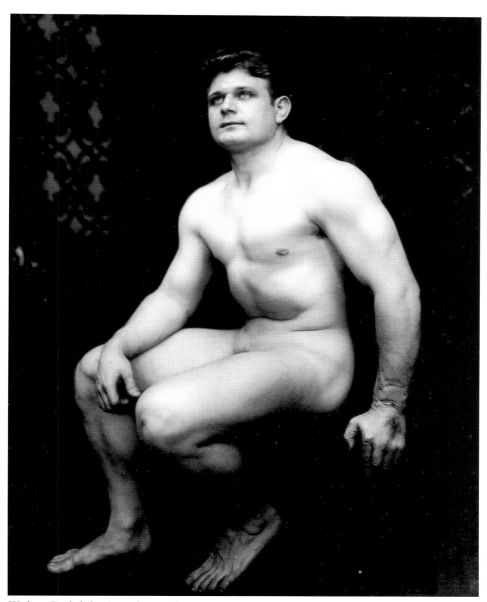

Walter Podolak; American, circa 1920

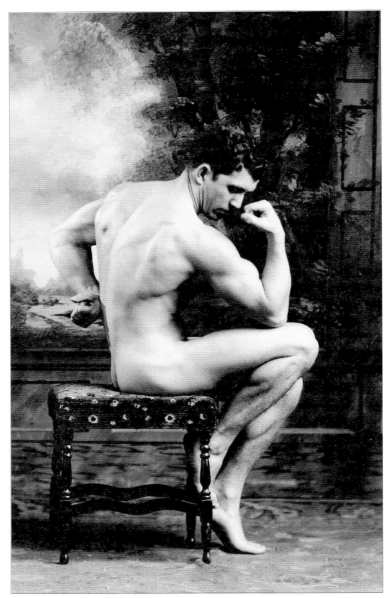

Joseph Kurpiel; American, circa 1930

FREIKÖRPERKULTUR and WAR

The sporting movement and physical culture had been born in the aftermath of war, and by the time the Great War of 1914-1918 arrived, exercise and muscle building had become established facts. This was so much the case that even amid the shocks and savagery of war, many of the troops on all sides found time to work out and stay healthy.

Many troops in Germany had been introduced to physical culture through the nudist movement, and this was destined to spread worldwide in the 1920's and 30's. The Freikörperkultur or nudist movement preached that freedom, purity and health could all be attained if one let the sun wash over the naked muscles. It was a pleasant philosophy for those pre-sunscreen days, and if it helped take the edge off the horrors of war, so much the better.

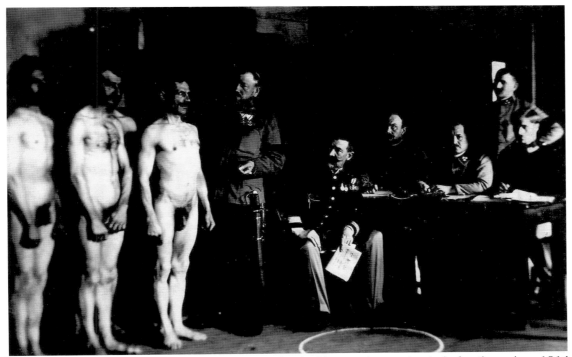

Naked German or Austrian soldiers wait for physical inspections prior to induction; circa 1914

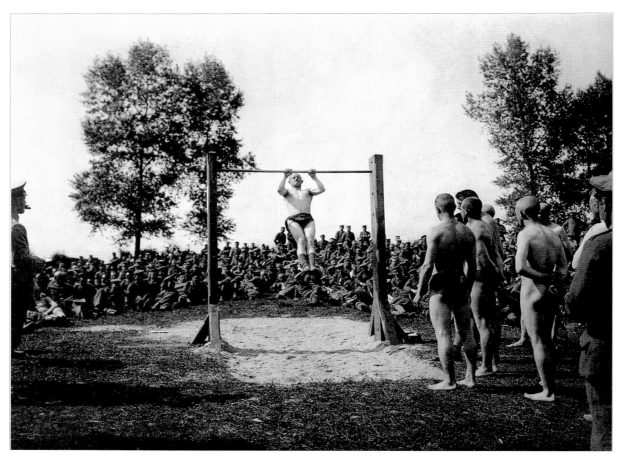

Athletic display behind the lines; German, 1916

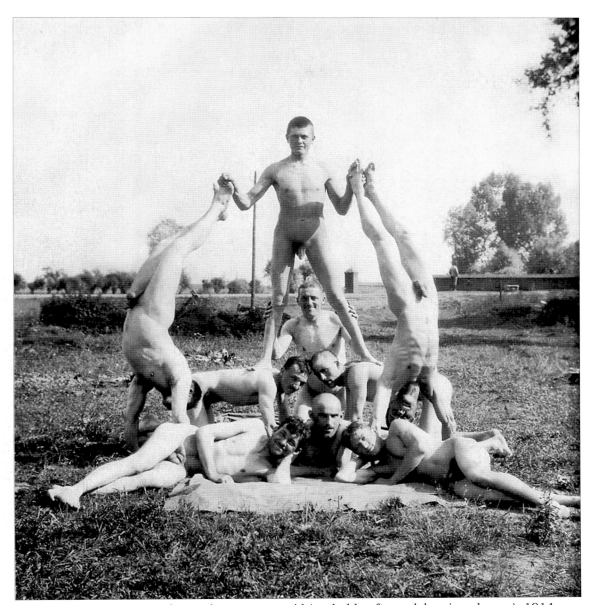

Naked German troops perform a human pyramid (probably after a delousing shower); 1914

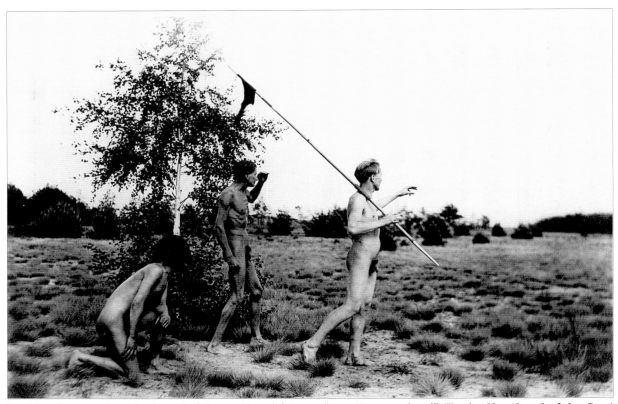

Looking forward to a better, clothing-optional future: "Aus Neusonnland" (To the New Land of the Sun) taken by J.Baher near Berlin, 1925